$5 \times 2 = 10$ $10 - 60 = 504/50$ $\frac{13\frac{1}{2}}{50}$ $\boxed{12\frac{1}{2}}$ $4\frac{1}{2}$ $\frac{5}{2} + 1 = \frac{6}{2} = \frac{2}{6}$ of $60 = 20$

$\frac{4}{3)60}\frac{8}{13}$ $10 \times 11 = 110$ $\frac{4}{70}$ $4\frac{1}{2} \div 2 = 4\frac{1}{2} \cdot 2$

$\frac{52}{8}$ $11 \times 5\frac{1}{2} = 11 \times \frac{11}{2} =$ $\frac{110}{+11}$ $60\frac{1}{2}$ $2\frac{3}{4}$ 11 inch

$\frac{121}{121}$ $2|121|60\frac{1}{2} - \frac{37}{55}$

$2\frac{1}{2}$ $\times \frac{5}{4}$ $\frac{30}{4}$ $6\frac{6}{4}$ $7\frac{2}{4}$ $3 = 4\frac{4}{2} = 2\frac{1}{8}$

$+3\frac{1}{4}$ $\times 10$ $\frac{30}{4}$ $7\frac{5}{8} \div 7\frac{1}{2}$ $\frac{9}{8} \div \frac{15}{2}$

$5\frac{3}{4}$ 50 30 $\frac{18}{12}$ $60 \times 1\frac{1}{8} = 60 \times \frac{9}{8} =$ $67\frac{1}{2}$

$7 \quad 60$ $\frac{30}{22}$ $\frac{30}{0}$ $8\sqrt{540}$ $\frac{9}{8}$ $8\sqrt{5-40}$ $\boxed{67\frac{1}{2}}$ 60

$\frac{7}{14}\frac{14}{14}$ $4)46(11\frac{1}{2}$ $\frac{-0}{60}$ $\frac{60}{56}$ $\boxed{67\frac{1}{2}}$ $9)60\frac{6\frac{2}{3}}{54}$ $\frac{3}{8} \times 8$

$3\frac{1}{2} \div 4 = \frac{2}{7} \times 4 = \frac{8}{7} = 1\frac{1}{8}$ $1\frac{1}{7} \div 2\frac{56}{4}$ $1\frac{1}{7} \div 2 = \frac{8}{7} \times \frac{4}{7} = \frac{4}{7} = 4\frac{1}{8}$

$\times 3\frac{3}{8} = 13\frac{3}{2}$ $\frac{12}{8} = 1\frac{1}{2} = \boxed{13\frac{1}{2}}$ $\boxed{14\frac{1}{2}}$ $\frac{-60}{14\frac{1}{2}}$ $\boxed{11\frac{1}{2}}$ $14\frac{1}{2} \div 8$ $14\frac{1}{2} \div 8 = \frac{11\frac{1}{2}}{8}$

$13\frac{1}{2}$ $\frac{15\frac{3}{4}}{11\frac{3}{4}}$ $\frac{60}{55}$ $4)45\frac{1}{2}(11)$ $18\frac{1}{2}$ $\frac{29}{2} \times \frac{1}{8}$ $40\frac{1}{8}$ $10\frac{1}{8}$ $3\frac{1}{8} 3 \times 14$

$\frac{1}{2} \times 8 = 16$ $8 \times 2 = 4$ $4 \times 3\frac{3}{8} = 4 \times 2\frac{3}{8}$ $\frac{14}{4}$ $8)99\frac{12}{20}$ $1\frac{1}{8} \div 17 \quad 17$ $\boxed{34}$

$\times 3\frac{1}{8} = 15$ $\frac{1}{8} + \frac{1}{4}$ $4 \times 11\frac{5}{8} = 44\frac{20}{8}$ $5\frac{5}{8}\frac{8}{19}$ $12\frac{3}{8}$ $\frac{1}{2} \div \frac{6}{8} = 3\frac{3}{4}$ $\frac{9}{8} \div 17 = 68$

$11\frac{1}{2} \times \frac{1}{2} = 3\frac{3}{8}$ $\frac{45}{46}$ $1\frac{1}{8}$ 16 $2)7\frac{5}{8}(3\frac{6}{8} = 3\frac{3}{4}$ $9)136$

$\frac{2}{3} \times \frac{1}{2} = \frac{23}{4}$ $11\frac{5}{8}$ $4)56(4\frac{20}{16}(5$ $1-3-10-1-3-1$

$4 \times 8 = 32 + 2 = 34$ $4)56(42$ $1-4-10-1-10$ $3-7$

$\times 8 = 24 + 15 = 26\frac{60}{60}$ $2|16(8$ $1-3-10-1-10$ $8-2-5-2-52$

AGNES MARTIN

The Nineties and Beyond

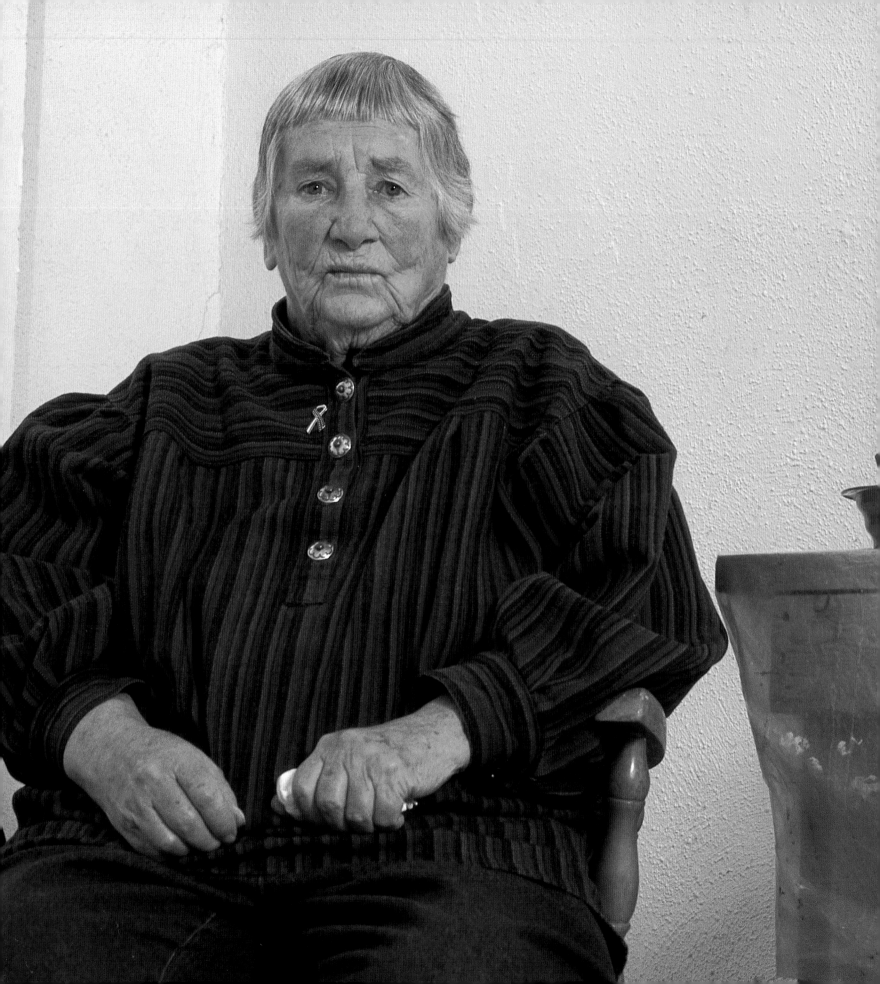

AGNES MARTIN

The Nineties and Beyond

Ned Rifkin

with a poem by

Edward Hirsch

THE MENIL COLLECTION

in association with

HATJE CANTZ

This catalogue accompanies the exhibition "Agnes Martin: The Nineties and Beyond."

The Menil Collection, Houston
February 1–May 26, 2002

The exhibition and catalogue are generously supported in part by:

an anonymous donor
Michael and Jeanne Klein
CHRISTIE'S
and Eliza Lovett Randall

Cover: Agnes Martin, *Untitled No. 9, 1995* (page 51)
Endpapers: Detail of a sheet of the artist's calculations
Frontispiece: Agnes Martin in her studio, Taos, November 2001

Photography:

Photographs of Agnes Martin and of her Taos studio (frontispiece; pages 12, 16, 24, 30, 108)
 © 2001 Cary Herz Photography, Albuquerque, New Mexico
Gordon R. Christmas: pages 81–89
Paula Goldman: pages 69–77
Maggie L. Kundtz: pages 55, 59
Ellen Page Wilson: cover, pages 33–53, 57, 62-67, 79, 91–107
Courtesy of the artist: page 113

Library of Congress Control Number: 2001099799

Published by:
Hatje Cantz Verlag
Senefelderstrasse 12
73760 Ostfildern-Ruit, Germany
tel 49.711.440.50
fax 49.711.440.5220
www.hatjecantz.de

Distributed in the U.S. by:
D.A.P., Distributed Art Publishers, Inc.
155 Avenue of the Americas, 2nd floor
New York, N.Y. 10013-1507
USA
tel 1.212.627.1999
fax 1.212.627.9484

ISBN 3-7757-1165-1
Printed in Germany

CONTENTS

Mr. and Mrs. Charles Diker

Collection of Frances Dittmer, Aspen

Robert and Esta Epstein, Boston

Collection of Mr. and Mrs. Robert I. Glimcher

Kip and Mary Ann Hagopian, Los Angeles

High Museum of Art, Atlanta, Georgia

Collection of Denise Howard, Denver

Collection of Maria and Conrad Janis, Los Angeles

Collection of Gordon Locksley and Dr. George T. Shea, Minneapolis

Mark and Margaux Maybell, Darien, Connecticut

Collection of Byron Meyer, San Francisco

Michael and Judy Ovitz Collection, Los Angeles

Private Collection, courtesy PaceWildenstein

The Rachofsky Collection, Dallas

Ivan and Genevieve Reitman, Santa Barbara, California

Ann and Chris Stack, Indianapolis

Anabeth and John Weil, St. Louis

Mr. and Mrs. David K. Welles

Collection of Michael Young, New York

Private Collection, Houston

Private Collection, New York

Private Collection, Pasadena, California

Private Collection, San Francisco

ACKNOWLEDGMENTS

Putting together any exhibition requires the efforts of numerous people, and *Agnes Martin: The Nineties and Beyond* is no exception. My thanks go to Robert Moskowitz, a wonderful artist in his own right, for putting me in direct contact with Agnes Martin several years ago. I am also grateful to James Kelly of Santa Fe, who was instrumental in facilitating my visits to the artist when I was beginning this exhibition.

I wish to thank Louisa Stude Sarofim, the president of the Menil Foundation, Inc., and members of its Board of Directors who enabled me to pursue this special undertaking. To an anonymous donor, Michael and Jeanne Klein, Christie's, and Eliza Lovett Randall goes my gratitude for underwriting support that has made a real difference.

Arne Glimcher and Douglas Baxter and their staff at PaceWildenstein in New York have brought to this project their unflinching commitment to Agnes Martin and her art. I am also extremely indebted to the lenders to this exhibition, listed on page 9, all the individual collectors and museums who enabled The Menil Collection to assemble these precious works. A number of collectors simply could not part with their paintings over the four months that comprise this exhibition's run, so I am all the more grateful to those who were willing to share these fragile works with viewers in Houston.

I want to thank my colleagues at The Menil Collection for their support and participation. Early on, Deborah Velders, head of exhibitions and design, was extremely helpful to me, as were my assistants Lana McBride and Kristin Schwartz-Lauster. In implementing the organization of the exhibition, Anne Adams, registrar, made arrangements for the transport of the artworks. Matthew Drutt, recently appointed chief curator, was quick to recognize the need for curatorial support, and Susan Braeuer capably handled the final phases of this project, her first at The Menil Collection. Will Taylor, Tripp Carter, and Mary Ann Pack all contributed substantially to garnering financial support for the exhibition and its publication. John Reed and his colleagues in the Menil Foundation's business office kept close track of all of our expenses and encouraged this project from the beginning. Vance Muse did a fine job of bringing public attention to this effort. To the art services crew, Bear Parham,

Doug Laguarta, and Tom Walsh, go my sincere thanks for enabling this exhibition to find its final form within the gracious Menil Collection spaces.

I am also very fortunate to have had the expert editorial assistance of Alice Gordon. It was her response to my early efforts to define this exhibition that also yielded the concept for the title of my essay, "The Music of the Spheres." Don Quaintance of Public Address Design worked skillfully on the design of the catalogue and collateral printed material, from invitations to posters. I wish to thank Polly Koch for her insightful editing of the manuscript.

It is also my pleasure to recognize the outstanding work of poet Edward Hirsch, who bravely agreed to accept the commission of a poem on the occasion of this exhibition. Writing poetry is not easily done on demand, but from the beginning of our collaboration, Ed's genial yet serious approach to his subject impressed and encouraged me. I am pleased to publish the poem in this exhibition catalogue.

Finally, I am grateful to the artist herself for granting me permission to mount this exhibition. With work that speaks so eloquently about her commitment to the spheres of creativity and the soul, Agnes Martin has been an inspiration to many people for many years. I feel privileged to have worked with an artist of her achievement and thank her for permitting me the honor of celebrating this remarkable decade of her work.

—Ned Rifkin

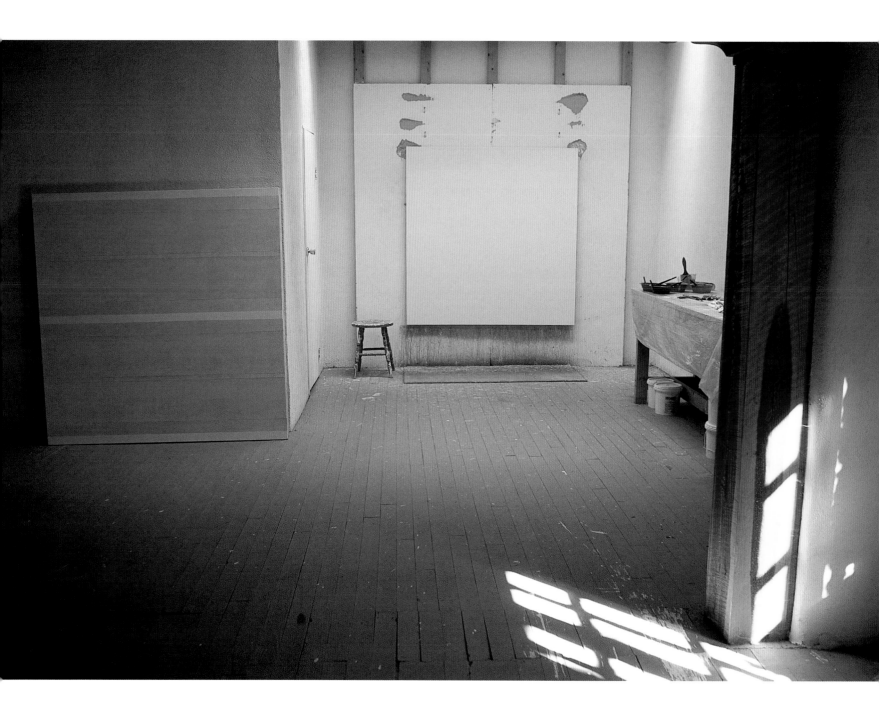

Two years ago, when a committee of the Menil Foundation's Board of Directors asked me which artists I thought were missing from the permanent collection, Agnes Martin was the first name that came to mind. I could not imagine a more appropriate match between an artist's sensibility and the disposition of an architectural space. The "breathing" light and space of The Menil Collection building and the exquisite proportions of the walls invite the elegance and resonance of Agnes Martin's work. That she would be turning ninety years old in March 2002 presented the perfect fusion of occasion and opportunity.

The idea for an exhibition had been percolating since 1994, when I made my first visit to the artist's studio in New Mexico; she had recently moved to Taos from a more remote area of the state. On the morning I drove from Santa Fe up to Taos, I arrived at Martin's home to find her sitting in her rocking chair in the living room, her eyes closed in meditation. I told her that I had admired her work for many years, ever since I first saw it at The Museum of Modern Art in New York when I was a young art history student. To my surprise, she knew precisely which painting and began to describe it in minute detail. (Only later in the day did she tell me that it had been the first of her works to enter a museum collection.)

We had a pleasant morning getting to know one another at her home and at the studio, the smallness of which astonished me. Many artists in New York and other cities work in extremely limited areas, but more often by financial necessity than desire. Martin's place, on the other hand, though small, is simple, cozy, and modest, not at all cramped. It suggests a stripped-down view of her needs, clearly all the room she feels she needs.

Agnes Martin's studio,
Taos, New Mexico,
November 2001

We talked about many things, but I remember best her answers to two of my flat-footed questions. The first was whether she "composed" her paintings, making adjustments to arrangements of line, color, and formal design as she worked, or whether she was painting something that she saw. "I wait for inspiration," she said clearly. "I sit and I empty my mind and wait for the images to appear."

"Then you are rendering what you see?"

"Yes," she said. Although at the time I couldn't have said why, I was not surprised by her response.

The other question had to do with why she left New York in 1967. Her answer this time *did* surprise me: "I think it is more important to figure out where you want to be than it is what you want to do. First you have to find where you need to be, and then you can do what you need to do." An artist of considerable reputation well before she temporarily stopped painting, she seemed to be saying that place had been at one time more important than making art.

On the drive back down toward Santa Fe, my head full of Martin's paintings and terse insights, I stopped by a small church called El Sanctuario del Chimayó, which my friend the painter Gregory Amenoff had told me I must see; it was known among many artists as a highly spiritual place. Even before I got out of the car, I sensed a palpable vibration around it. The small, enchanting interior space also was powerfully charged, redolent in many ways of my experience of Martin's studio earlier in the day.

I did not stay very long. The sun was starting to descend in the big desert sky. As I drove from Chimayó toward Santa Fe, the orange light seemed to pool into the undulating forms of the desert landscape all around me, a liquid impression of light that I had never had before. Suddenly, as the sky started to redden, I was gripped by the sensation of being underwater. I thought about the water that once had moved and shaped this land, when it had been the bottom of the sea. I had always assumed that my own strong attraction to water, my feeling of comfort in proximity to oceans, lakes, and rivers, had something to do with a primal knowledge that we emerged as life forms from the sea. Now it occurred to me that if the ocean had given us life, then the desert might be the locus of the "after-life." Perhaps mystics who wandered in the desert were drawn to an earthly prefiguration of a world to come.

Years later, I came across this quotation from Martin: "My paintings have neither object nor space nor line nor anything—no forms. They are light, lightness, about

merging, about formlessness, breaking down form.... [It] is to accept the necessity of the simple, direct going into a field of vision as you would cross an empty beach to look at the ocean." The artist, a latter-day mystic in the desert, was evoking the ocean as a metaphor for the yearnings defined by her work; her words confirmed the deep connection I had felt to her work on that first visit, which has only deepened more in the years since.

The Menil Collection offers this exhibition of Agnes Martin's paintings made between 1993 and early 2002 as a tribute to the "late works" of a giant of an artist. Although Martin was celebrated and honored with a definitive retrospective mounted in the fall and winter of 1992 and 1993 by Barbara Haskell of the Whitney Museum of American Art, New York, The Menil Collection's exhibition reveals that Martin has continued to mine her severely restricted artistic vocabulary with ever richer results. She regularly—and rigorously—edits her work. On one recent visit to her studio, I was looking at three or four new paintings when she mentioned that she was going to throw them out. At least one was as stimulating to my eyes as any I had already selected for this exhibition. She could not be dissuaded. Martin knew what was "wrong" with the painting and was certain that it was not salvageable. She tossed the lot out. Her conviction and determination have yielded an inestimable body of work.

Martin is not one to speak about her work specifically. She prefers that the pictures speak for themselves. One does not necessarily find "meaning" in her works, in the conventional sense, any more than one finds "image." Her paintings require from the viewer a predisposition to see what is and what is *not* present, to accept what is visible and available. There is no narrative. There are color, line, proportion, and energy. My hope, in presenting this exhibition of thirty-five paintings, is not for visitors to The Menil Collection to *understand* Agnes Martin's paintings, but rather for them to feel the special energy of the works and to engage with their unique dynamics. They are resonant evocations of the artist's spirit. They are alive with gentle emanations. They are the essence of the creative enterprise.

—*Ned Rifkin*

page 16:
Agnes Martin in her studio, Taos,
New Mexico, November 2001

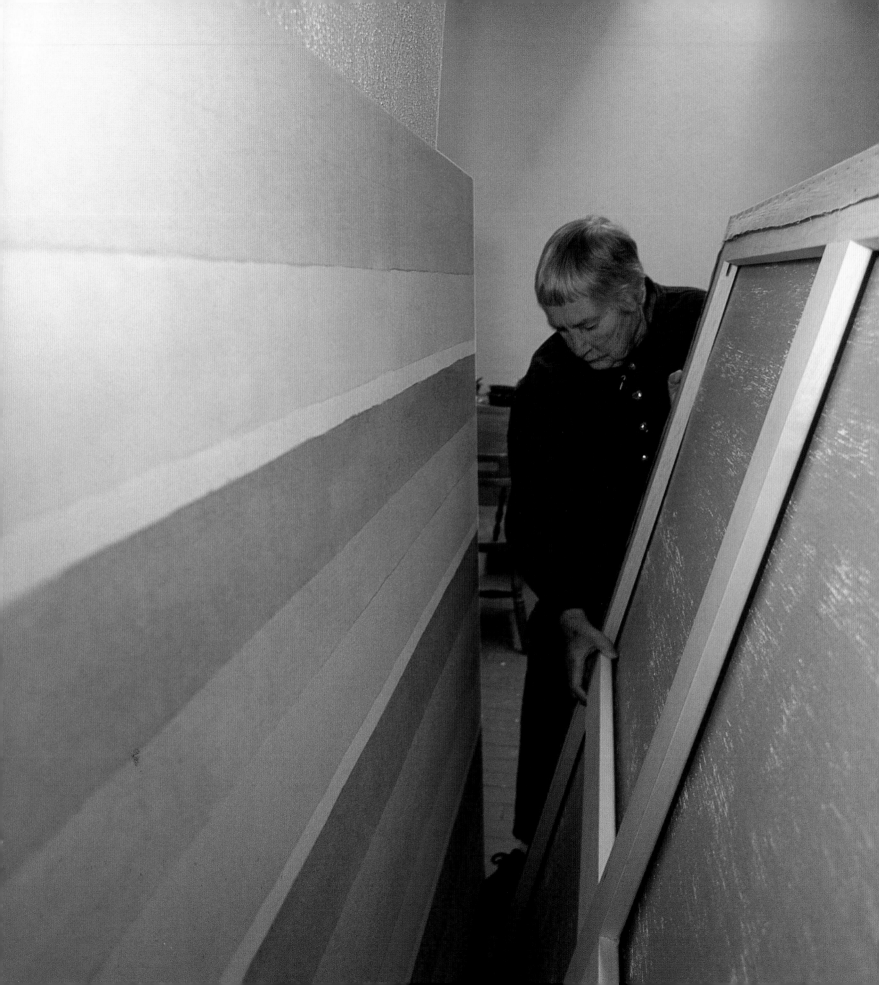

THE HORIZONTAL LINE

(Homage to Agnes Martin)

It was like a white sail in the early morning

——

It was like a tremulous wind calming itself
After a night on the thunderous sea

——

The exhausted lightning lay down on its side
And slept on a bed of cumulous sheets

——

She came out of the mountains
And surrendered to the expansiveness of a plain

——

She underlined a text in *Isaiah:*
Make level in the desert
A highway for our God
Every valley shall be exalted
And every mountain and hill shall be made low

——

The mountain grew tired of striving upward
And longed to flatten its ragged peaks

———

The nostalgia of a cathedral for the open plain

———

The nostalgia of a soprano for plainsong

———

I know a woman who slept on a cot
And sailed over the abyss on a wooden plank

———

She looked as far as the eye can see
But the eye is a circle—poor pupil—
And the universe curved

———

It was like a pause on the Bridge of Sighs
An instant before the storm
Or the moment afterward

———

My friend listened to Gregorian chants
On the car radio as he raced down
A two-lane highway in southern France

———

I remember riding a bicycle very fast
On a country road where the yellow line
Quivered ever so slightly in the sun

————

The faint tremor in my father's hand
When he signed his name after the stroke

————

The beauty of an imperfection

————

An almost empty canvas turned on its side
A zip that forever changed its mind

————

From its first pointed stroke
To its last brush with meaning
The glow of the line was spiritual

————

How the childlike pencil went for a walk
And came home skipping

————

It was like lying down at dusk to rest
On the cool pavement under the car
After a blistering day in the desert

————

The beaded evanescence of the summer heat

———

The horizon was a glimmering blue band
A luminous streamer in the distance

———

I recited, *Brightness falls from the air*
And the line suddenly whisked me away

———

No chapel is more breathtaking
Than the one that has been retrieved
On the horizon of memory

———

She remembered the stillness of a pool
Before the swimmers entered the water
And the colorful ropes dividing the lanes

———

Each swimmer was a scar in the blue mist

———

Invisible bird,
Whistle me up from the dark on a bright branch

———

It's not the low murmur of your voice
Almost breaking over the phone
But the thin wire of grief
The hum of joy that connects us

———

Sacred dream of geometry,
Ruler and protractor, temper my anguish,
Untrouble my mind

———

Heartbeat, steady my hand

———

Each year she crossed a line
Through the front page of a fresh diary
And vowed to live above the line

———

She would not line up with others
She would align herself with the simple truth

———

She erased every line in her notebook but one
Farewell to the aspirations of the vertical
The ecstasies of the diagonal
The suffering cross

———

Someone left a prayer book open in the rain
And the printed lines blurred
Ink smudged our fingers when we prayed

——

Let every line be its own revelation

——

The line in the painting was surrounded by light
The light in the painting held its breath
On the threshold of a discovery

——

If only she could picture
The boundlessness of God drawing
An invisible thread through the starry spaces

——

If only she could paint
The horizon without limits

——

A horizontal line is a pilgrimage

———

A segment of devotion wrested from time

———

An infinitely gentle mark on a blank page

———

The stripe remains after everything else is gone

———

It is a wisp of praise with a human hand

———

It is singing on a bare canvas

Edward Hirsch

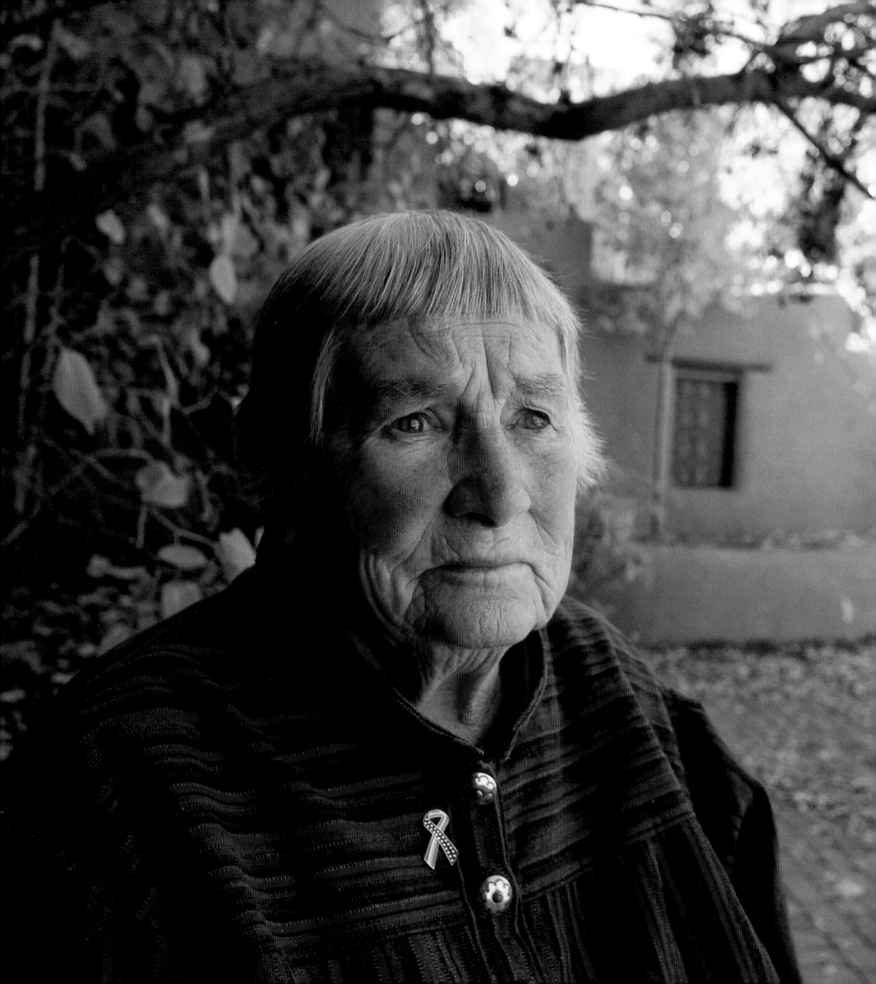

AGNES MARTIN—THE MUSIC OF THE SPHERES

Ned Rifkin

> My interest is in experience that is wordless and silent, and in
> the fact that this experience can be expressed for me in art
> work which is also wordless and silent.
>
> Agnes Martin
> [From "The Still and Silent in Art"]

How does one write about the ineffable? What can possibly be said about purely visual phenomena that does not compromise its essence? We talk and write about visual art because we feel we must if we are to discover its meaning. Agnes Martin's work of the last several years is mysteriously magnetic, yet there is so little in it to hold onto, so little on which to get one's footing, that the paintings seem to defy articulation and our desire to assign meaning to them.

It is possible to describe, if not define, the work and make some discoveries in the process: the tracery of pencil lines drawn at consistent increments of space reveals an irregular hand, one that stops and restarts to span the width of the canvas, using a simple ruler to guide each line's implicit parallel relationship to the edges of the top and bottom of the canvas. Martin's compositions are symmetrically derived around a central horizontal divide. This balanced approach to dividing the painted area of the canvas discloses the artist's propensity for geometric order. Yet it is the irregularities within this context of geometrical order and symmetry that uncover the humanity of the artist's touch.

Geometry is an abstract system of order concerned with the relation between shapes. It is also an ideal. It refers to a perfection of form that does not actually exist within the natural world. In contrast, the rectangles Martin describes within the square

Agnes Martin outside her studio, Taos, New Mexico, November 2001

format of her canvases are irregular and imperfect. "I hope I have made it clear that the work is *about* perfection as we are aware of it in our minds," the artist said in 1973, "but that the paintings are very far from being perfect—completely removed in fact—even as we ourselves are." Handmade geometry sets the human reality against Pythagorean perfection, a perfection that only gods might be able to realize. Thus, Martin seems to suggest, the purely geometric is analogous to the spiritual.

Color in Martin's late paintings serves a function comparable to that of formal design or composition. The way she deploys color alludes to the workings of light rather than to objects of color. Her pale blues are not remote and cool, nor are her yellows hot. Because the paint is diluted acrylic and combines with the chalky whites of her gesso, Martin's colors both absorb and reflect light. This unusual way of handling color, as if to impart a feel or an "aroma" rather than to create temperature or to mimic naturalistic color, characterizes much of Martin's work over the past several years. Her hues, so masterfully washy, are liquid intimations of color. They are also fields of space that recede and advance in relation to one another.

There is a canny quality to how these paintings activate the senses. Nothing is terribly surprising. The gentle colors induce tranquility, reassuring the eyes rather than arresting our attention or aggressively stimulating us with chromatic splashes. Color in Martin's paintings seems to massage the cones within the eye, offering its light outward in a modest, untrammeled way. The color is contained by those fragile linear graphite boundaries: the edges of the color fields are not emphatically demarcated, and yet the color "behaves," holding the described form but optically suggesting that it just as easily could bleed outside of the rectangle containing it. Martin's insistence on delineated space appears to be offset by a willingness to allow accidents to occur. Perhaps a "leak" of color here or there would not intrude upon the next area but merely merge with it.

Since moving to Taos in 1993, working in a small studio near her residence, Martin has reduced the size of her major paintings from a six-foot square to a five-foot square. The difference in area between the earlier size and the most recent one is a mere eleven square feet. Yet this seemingly slight change has introduced a new intimacy of scale and simultaneously opened her work to a decidedly more lyrical tone in color and feeling. With these small, yet significant, changes comes another phenomenon: Martin has extended her visual language from one that embodies densely

focused fields of opaquely painted surfaces to one whose vocabulary stresses vaporous emanations of ethereal light, like that of the New Mexico landscape in which she works.

She also has begun to title her paintings for the first time since 1967, the year she stopped painting, left New York City, and moved to Cuba, New Mexico. (She began to paint again, full force, seven years later, in 1974, after a survey of her work was presented in Philadelphia by the Institute of Contemporary Art.) The resumption of titles echoes the later work's shift in sensibility and surface. In the 1960s, Martin's titles—for example, *The Cliff, The Leaves, The Rose*—alluded directly to the natural world. The titles of the past few years are exuberant, even ecstatic, in tone: *Beautiful Life, Tranquility, Happiness-Glee, I Love the Whole World.* Except for *With My Back to the World* (the 1997 series that seems to describe the artist's position outside conventional social order and the world of appearances), the newer titles evoke Martin's embrace of sheer goodness, pervasive well-being, and a joyous sense of the sublime. With these clues provided by the painter, it is tempting to "read" the works with more specific overtones, for the paintings seem to emit a warm glow, inviting viewers to bask in a positive energy.

In the history of modern art, Martin's work might best be placed alongside that of artists whose quest has been to find the abstract sublime, those who aspire through nonrepresentational means to a "spiritual otherness." The most obvious early twentieth-century precursors include the Russian Suprematist works of Kasimir Malevich and the Dutch Neo-Plastic compositions of Piet Mondrian. More recent kindred spirits include the mid-century American painters Mark Rothko and Barnett Newman, especially important because they created the genre into which Martin's late work is best considered.

Against the backdrop of the "action painting" of Jackson Pollock, Franz Kline, Willem de Kooning, and other Abstract Expressionists, Rothko's paintings were deliberately less gestural, with hovering pillows of color emerging ever so slowly from the ether of larger fields of contrasting color. Rothko's work appears to have grown from a desire to find in painting a visual analogue to prayer—not religious prayer, in the sense of ceremony attached to a specific belief system, but prayer as the invocation of a power or spirit beyond the rational. This is where the nexus between Rothko's and Martin's recent work is most clear. In fact, the Rothko Chapel, the

project commissioned by John and Dominique de Menil in the mid 1960s, may be what inspired Martin's series of paintings entitled *Islands* and her more recent commissions such as *With My Back to the World*.

In Newman, Martin found a kindred spirit; she was drawn to the insistent succinctness of his paintings and the "oneness" of his fields, which were segmented dramatically and definitively by so-called "zips," his vertical lines from the top to the bottom of the canvas. The mutual respect between Martin and Newman, manifest in his willingness to help her install her exhibitions at Betty Parsons' gallery in the late 1950s, had a lasting impact on her. Although Newman's titles indicate that his work has both a poetic and a programmatic meaning, his paintings are nonspecific and without image, decidedly more tonal in spirit than those of the majority of the New York School painters. Martin adapted Newman's rigorous orthodoxy and spare geometry, making them potent components of her own evolving visual language. Martin's mature work of the 1960s through the late 1980s shows much evidence of Newman's influence, and the allowance for the hand in the paintings she began in the early 1990s departs from Newman to achieve a more intimate tone and texture.

For more than five decades, Martin has created paintings that are evocations of light, each an individual issuance of ethereal rhythms. Simultaneously powerful and gentle, they are spartan works, beautiful without the slightest adornment. The paintings that Martin has offered us with unstinting consistency are not pictures *of* anything. They are cadences of light, form, and color. You can "hear" them with your eyes. They are silent sounds.

One impulse of many nonrepresentational painters in the early decades of the twentieth century was to find an analogue for the high-minded aspects of musical composition. Czech painter František Kupka, the Frenchman Robert Delaunay, and Russian artist Wassily Kandinsky—the three often considered to be the creators of art that would forever distinguish the past century from the previous ones—all made musical references as they explored the uncharted territories of nonrepresentational art. Martin makes no such reference herself, but it is tempting to think of her recent work as "chords" of color and horizontal form. There is the literal reference to the musical staff that holds the notes of the composer, though Martin's "staffs" contain no "notes" or corresponding "sounds." The lines are also like the strings of instruments

awaiting the touch of the performer. So Martin invites us to "play" her painting with our eyes, minds, and spirits.

It was Pythagoras, the sixth-century B.C. Greek philosopher and mathematician, who developed the notion of "The Music of the Spheres." He speculated that the movement of the heavenly bodies, the rotations and revolutions of the planets, stars, and moons, created harmonious sounds. If one heard this "music," then one would be in touch with a greater harmony than existed merely on Earth. Martin makes no claims to the capacity for such music, but her work may have extended visual art to this level of experience. In her ability to render these remarkably simple works of spare beauty, she has opened us to something available only if we pay close attention to how our inner spirit connects to the stirrings of the cosmos.

page 28:
Agnes Martin's worktable
in her studio, Taos, New
Mexico, November 2001

CATALOGUE OF THE EXHIBITION

UNTITLED No. 1
1993

Acrylic and graphite on canvas
60 x 60 inches
The Rachofsky Collection, Dallas

UNTITLED No. 2
1993

Acrylic and graphite on canvas
60 x 60 inches
Ann and Chris Stack, Indianapolis

UNTITLED No. 3
1993

Acrylic and graphite on canvas
60 x 60 inches
Collection of Byron Meyer, San Francisco

UNTITLED No. 3
1994

Acrylic and graphite on canvas
60 x 60 inches
High Museum of Art, Atlanta, Georgia;
Purchase in honor of Pat D'Alba Sabatelle, President of the Members Guild
of the High Museum of Art, 1995–96, with funds from Alfred Austell Thornton
in memory of Leila Austell Thornton and Albert Edward Thornton, Sr.,
and Sarah Miller Venable and William Hoyt Venable

UNTITLED No. 6
1994

Acrylic and graphite on canvas
60 x 60 inches
Private Collection, courtesy PaceWildenstein

UNTITLED No. 8
1994

Acrylic and graphite on canvas
60 x 60 inches
Ivan and Genevieve Reitman, Santa Barbara, California

UNTITLED No. 2
1995

Acrylic and graphite on canvas
60 x 60 inches
Anabeth and John Weil, St. Louis

UNTITLED No. 5
1995

Acrylic and graphite on canvas
60 x 60 inches
Collection of Gordon Locksley and Dr. George T. Shea, Minneapolis

UNTITLED No. 8
1995

Acrylic and graphite on canvas
60 x 60 inches
Robert and Esta Epstein, Boston

UNTITLED No. 9
1995

Acrylic and graphite on canvas
60 x 60 inches
Private Collection, San Francisco

UNTITLED No. 18
1995

Acrylic and graphite on canvas
60 x 60 inches
Mr. and Mrs. David K. Welles

UNTITLED No. 4
1996

Acrylic and graphite on canvas
60 x 60 inches
Mr. and Mrs. Charles Diker

UNTITLED No. 1
1998

Acrylic and graphite on canvas
60 x 60 inches
Private Collection, Pasadena, California

UNTITLED No. 3
1998

Acrylic and graphite on canvas
60 x 60 inches
Private Collection

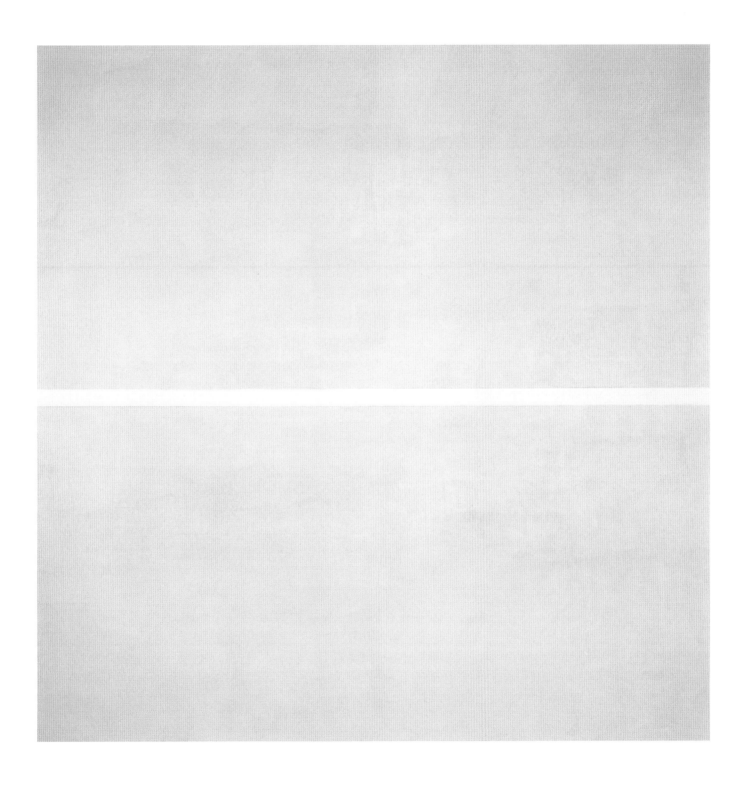

UNTITLED No. 11
1998

Acrylic and graphite on canvas
60 x 60 inches
Kip and Mary Ann Hagopian, Los Angeles

UNTITLED No. 12
1998

Acrylic and graphite on canvas
60 x 60 inches
Collection of Denise Howard, Denver

UNTITLED No. 13
1998

Acrylic and graphite on canvas
60 x 60 inches
Collection of Mr. and Mrs. Robert I. Glimcher

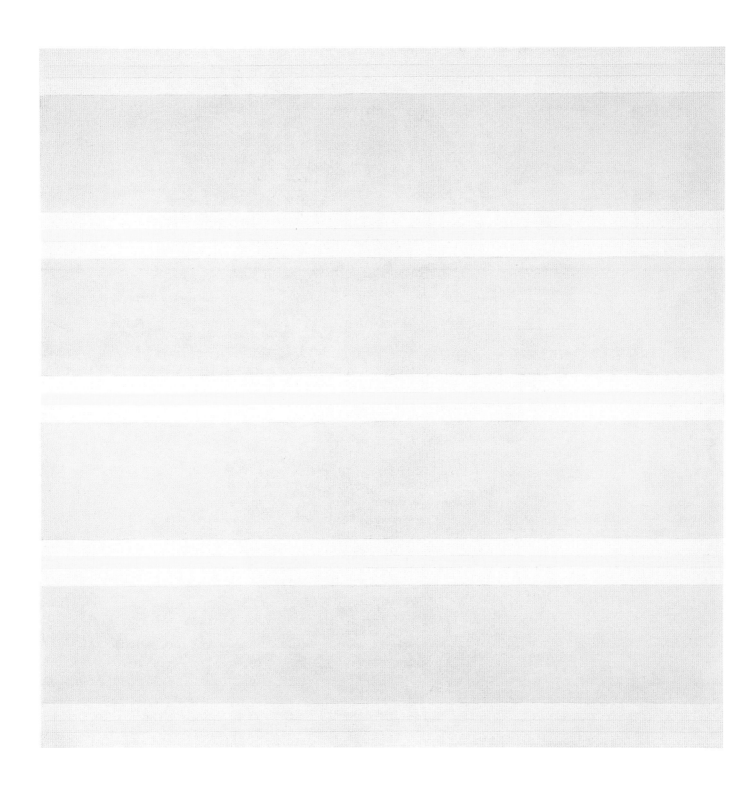

UNTITLED No. 13
1999

Acrylic and graphite on canvas
60 x 60 inches
Private Collection, Switzerland
Not in the exhibition

INFANT RESPONSE TO LOVE
1999

Acrylic and graphite on canvas
60 x 60 inches
John and Mary Pappajohn, Des Moines, Iowa
Not in the exhibition

LOVELY LIFE
1999

Acrylic and graphite on canvas
60 x 60 inches
Collection of Maria and Conrad Janis, Los Angeles

I LOVE THE WHOLE WORLD
1999

Acrylic and graphite on canvas
60 x 60 inches
Private Collection

HAPPINESS – GLEE
1999

Acrylic and graphite on canvas
60 x 60 inches
Private Collection, Seattle
Not in the exhibition

I LOVE LOVE
1999

Acrylic and graphite on canvas
60 x 60 inches
Mark and Margaux Maybell, Darien, Connecticut

LOVE AND GOODNESS
2000

Acrylic and graphite on canvas
60 x 60 inches
Private Collection

LOVE AND GOODNESS
2000

Acrylic and graphite on canvas
60 x 60 inches
Private Collection

BEAUTIFUL LIFE
2000

Acrylic and graphite on canvas
60 x 60 inches
Collection of Michael Young, New York

A LITTLE GIRL'S RESPONSE TO LOVE
2000

Acrylic and graphite on canvas
60 x 60 inches
John and Mary Pappajohn, Des Moines, Iowa
Not in the exhibition

LOVING LOVE
2000

Acrylic and graphite on canvas
60 x 60 inches
Private Collection, Houston

I LOVE THE WHOLE WORLD
2000

Acrylic and graphite on canvas
60 x 60 inches
Private Collection

TRANQUILITY
2000

Acrylic and graphite on canvas
60 x 60 inches
Private Collection, New York

TRANQUILITY
2001

Acrylic and graphite on canvas
60 x 60 inches
Private Collection

LITTLE CHILDREN PLAYING WITH LOVE
2001

Acrylic and graphite on canvas
60 x 60 inches
Private Collection, courtesy PaceWildenstein

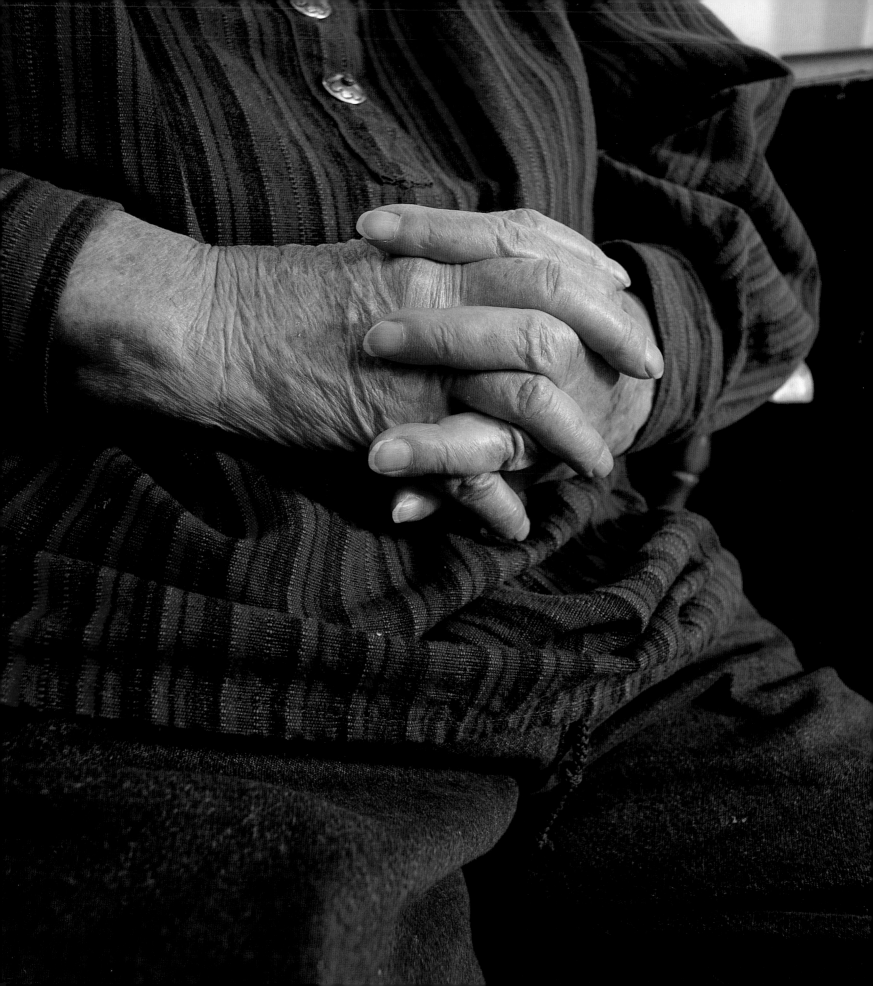

CHRONOLOGY

SELECTED EXHIBITION HISTORY

SELECTED BIBLIOGRAPHY

1912

Born Agnes Bernice Martin on March 22 in Maklin, Saskatchewan, Canada, to Margaret Kinnon and Malcolm Ian Martin, a wheat farmer. Agnes is the third of four children: Ronald, Mirabell, Agnes, and Malcolm Hand.

1914

After her father dies, moves with her family to the home of her grandfather, Robert Kinnon, with whom she closely bonds.

1919

Moves to Vancouver, British Columbia, where she spends her youth.

1931

Moves to Bellingham, Washington, in March to assist her pregnant sister.

1934–37

Soon after graduating from Whatcom High School, Bellingham, studies at Western Washington College of Education, Bellingham.

1941–46

Attends the Teachers College, Columbia University, New York, majoring in fine arts and art education. Receives a bachelor of science degree from Columbia in October 1942. Spends the next four years both teaching and painting.

1946–48

Enrolls in the art department at the University of New Mexico, Albuquerque, where she teaches art in 1947–48.

1950

Becomes a United States citizen.

page 108:
Agnes Martin in
her studio, Taos,
New Mexico,
November 2001

1951–52

Returns to the Teachers College, Columbia University, and receives a master of arts degree within a year.

In the fall of 1952, teaches at Eastern Oregon College, La Grande, Oregon.

1954

Returns to the Teachers College, Columbia University, for postgraduate study, taking "Seminar in Social Living."

Leaves New York for Taos, New Mexico, in the fall.

1957

Returns to New York and lives at 27 Coenties Slip in Lower Manhattan; her neighbors include Robert Indiana, Ann Wilson, and Lenore Tawney.

1958

First solo exhibition at Betty Parsons Gallery, New York, one of the first galleries to support the work of the Abstract Expressionists; her association with Parsons continues through December 1961.

1962

First solo exhibition at Robert Elkon Gallery, New York, which represents her through 1974.

1966

Participates in "Systemic Painting" at the Solomon R. Guggenheim Museum, New York, where her work is celebrated as Minimalist, although she soon after declares herself an Abstract Expressionist.

Receives a grant from the National Endowment for the Arts.

1967–68

Abandons painting immediately after her exhibition at Nicholas Wilder Gallery, Los Angeles; after touring the West and Canada in a pickup truck and camper for a year and a half, she settles in Cuba, New Mexico.

1973

First retrospective exhibition at the Institute of Contemporary Art, University of Pennsylvania, Philadelphia.

Publishes a suite of prints, *On A Clear Day*, with Parasol Press, New York.

First solo exhibition outside the United States at Kunstraum München.

1974

Constructs a studio near her house in Cuba and returns to painting after her lengthy

hiatus, producing works that depart from all associations with nature and empirical reality.

1975
First exhibition at The Pace Gallery, New York; Pace, now PaceWildenstein, remains her dealer today.

1976
Produces a feature film, *Gabriel*.

1977
Leaves Cuba and moves to Galisteo, New Mexico.

Solo exhibition at the Hayward Gallery, London, presented by the Arts Council of Great Britain; the exhibition travels to the Stedelijk Museum, Amsterdam.

1978
Accepts a medal from the Skowhegan School of Painting and Sculpture, Skowhegan, Maine, where she becomes an artist-in-residence in 1987.

1982
First solo exhibition in Canada at Centre Saidye Bronfman, Montreal.

1989
Inducted as a member of the American Academy and Institute of Arts and Letters, New York.

1991
Exhibition of works from 1974–1990 at the Stedelijk Museum, Amsterdam; the exhibition travels throughout Europe.

Receives the Alexej von Jawlensky Prize from the city of Wiesbaden, Germany.

1992
Publishes a bilingual edition of her writings in conjunction with a solo exhibition at Kunstmuseum Winterthur, Switzerland.

Receives in March the Oskar Kokoschka Prize from the Austrian government for international achievement in the fine arts.

1992–94
Major retrospective at the Whitney Museum of American Art, New York; the exhibition travels throughout the United States and to Madrid.

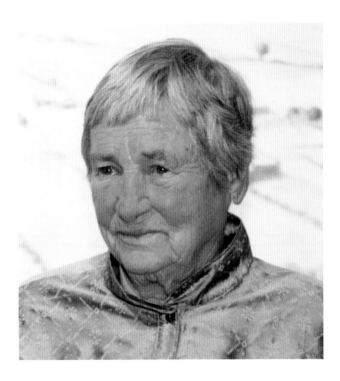

Agnes Martin, Taos,
New Mexico, 2001

1993
Moves to Taos, New Mexico, where she continues to reside and work today.

1995
Participates in the "1995 Biennial Exhibition" at the Whitney Museum of American Art, New York.

1997
Receives the Golden Lion for Contribution to Contemporary Art at the Venice Biennale.

Opening of the Agnes Martin Gallery at the Harwood Museum in Taos, New Mexico, permanently displaying seven horizontal line paintings produced in 1993.

1998
Receives the Distinguished Artist Award for Lifetime Achievement from the College Art Association; a National Medal of Arts from the Office of the President and the National Endowment for the Arts; and the 25th Annual Governor's Award for Excellence and Achievement in the Arts from Governor Gary Johnson, New Mexico.

One-Person Exhibitions, 1993–2001

1993

Wildenstein Gallery, Tokyo, May 17–June 30.

"Agnes Martin: Paintings and Drawings 1977–1991," Serpentine Gallery, London, September 8–October 24.

1994

"Agnes Martin: Paintings from 1991 & 1992," Galerie Michael Werner, Cologne, January 22–March 5.

Museum of Fine Arts, Museum of New Mexico, Santa Fe, March 26–May 15.

"Agnes Martin: Recent Paintings," Stockholm Konsthall, Magasin 3, Stockholm, May 26–September 8.

1995

"Agnes Martin Recent Paintings," PaceWildenstein, New York, February 17–March 18.

"Agnes Martin," MacKenzie Art Gallery, Regina, Saskatchewan, Canada, April 15–June 18; traveled to University Art Museum and Pacific Film Archive, Berkeley, California, July 12–September 24.

1996

"Agnes Martin: New Paintings," PaceWildenstein, Los Angeles, January 10–February 3.

"Agnes Martin Painting & Drawing," Galerie Daniel Blau, Munich, early spring.

"Agnes Martin: New Drawings and Watercolors," PaceWildenstein, New York, March 28–April 27.

"Agnes Martin," Annemarie Verna Galerie, Zurich, May 21–July 20.

1997

"Agnes Martin: Recent Paintings," PaceWildenstein, New York, January 16–February 15.

Agnes Martin Gallery, Harwood Museum, Taos, New Mexico, opens October 31 (permanent installation).

1998

"Agnes Martin: New Paintings," PaceWildenstein, New York, March 27–April 25.

"Agnes Martin: Works on Paper," Museum of Fine Arts, Museum of New Mexico, Santa Fe, May 15–August 17.

"Agnes Martin," Galeria 56, Budapest, June 2–July 4.

"Agnes Martin: New Paintings," PaceWildenstein, Los Angeles, October 8–31.

1999

"Agnes Martin: New Paintings," 1999 Edinburgh International Festival, Inverleith House, Royal Botanic Garden, Edinburgh, August 14–October.

2000

"Agnes Martin," PaceWildenstein, New York, April 27–June 10.

"Lovely Life: The Recent Work of Agnes Martin," Whitney Museum of American Art, New York, October 1–29.

2001

"Agnes Martin Recent Works," Anthony d'Offay Gallery, London, March 1–April 6.

SELECTED BIBLIOGRAPHY

Exhibition Catalogues

Agnes Martin: Recent Paintings, April 27 –June 3, 2000. New York: PaceWildenstein, 2000.

Auping, Michael. *Agnes Martin/Richard Tuttle.* Fort Worth, Texas: Modern Art Museum of Fort Worth, 1998.

Bloem, Marja, ed. *Agnes Martin: Paintings and Drawings 1974–1990.* Amsterdam: Stedelijk Museum, 1991.

Brandauer, Aline C., Harmony Hammond, and Ann Wilson. *Agnes Martin: Works on Paper.* Sante Fe: Museum of Fine Arts, Museum of New Mexico, 1998.

Haskell, Barbara. *Agnes Martin.* New York: Whitney Museum of American Art, 1992.

Peyton-Jones, Julia, and Emma Anderson. *Agnes Martin: Paintings and Drawings 1977–1991.* London: Serpentine Gallery, 1993.

Richmond, Cindy, and Lawrence Rinder. *Agnes Martin.* Regina, Canada: MacKenzie Art Gallery, and Berkeley, California: University Art Museum and Pacific Film Archive, 1995.

Books

Agnes Martin: Hiljaisuus Taloni Lattialla. Helsinki, Finland: Vapaa Taidekoulu, 1990.

Agnes Martin: Paintings and Writings. New York: PaceWildenstein, 2000.

Schwarz, Dieter, ed. *Writings/Schriften.* Winterthur, Switzerland: Kunstmuseum Winterthur/Edition Cantz, 1992.

Periodicals

Beaumont, Susanna. "Agnes Martin and John McLaughlin." *The List* (Edinburgh) (August 2, 1999): 64.

Bell, J. Bowyer. "Agnes Martin at PaceWildenstein." *Review Art* (February 1, 1997).

Collins, Tom. "Agnes Martin Reflects on Art & Life." *Geronimo* (Taos) (January 1999): 11, 13–15.

Cotter, Holland. "Agnes Martin: All the Way to Heaven." *Art in America* (April 1993): 88–97, 149.

_____. "Agnes Martin, 'New Drawings and Watercolors.'" *New York Times*, April 19, 1996, C21.

_____. "Art in Review: Agnes Martin." *New York Times*, March 3, 1995.

_____. "Like Her Paintings, Quiet, Unchanging, Revered." *New York Times*, Arts & Leisure Section, January 19, 1997, cover, 45.

_____. "Profiles: Agnes Martin." *Art Journal* (Fall 1998): 77–80.

Diehl, Carol. "Agnes Martin." *ARTnews* (October 1996): 136.

Euclaire, Sally. "New Agnes Martin Gallery." *ARTnews* (October 1997): 55.

Gardner, Paul. "Agnes Martin's New Work: Small and Light." *The Art Newspaper*, March 1995, 35.

Goff, Robert. "Agnes Martin's Chapel." *Out* (December 1998): 42.

Hayes, David. "Lines in the Desert." *Saturday Night* (December 1997/January 1998): 79–80, 82–84.

"High Five: Agnes Martin and John McLaughlin." *The List* (Edinburgh) (July 22, 1999): 24.

Horton, Sarah. "A Taos Triumph: Taoseños Ready the Harwood for Agnes Martin." *Local Flavor* (August/September 1997): 44–45.

Jeffrey, Moira. "Agnes Martin: New Paintings." *Sunday Herald/Festival Reviews* (Edinburgh), August 15, 1999, 13.

Johnson, Ken. "Agnes Martin/PaceWildenstein." *New York Times*, May 19, 2000, E34.

Jones, Jonathan. "Agnes Martin." Review of show at Anthony d'Offay Gallery. *The Guardian* (London), March 14, 2001.

Kent, Sarah. "Agnes Martin." Review of show at Anthony d'Offay Gallery. *Time Out* (London) (March 21–28, 2000).

Kohen, Helen L. "Exhibition *Is* Martin's Masterpiece." *The Miami Herald*, May 23, 1993, 11.

Kuspit, Donald. "Reviews: Agnes Martin." *Artforum International* (March 1993): 92.

Mitchell, Charles Dee. "A Metaphysics of Simplicity." *Art in America* (November 1998): 122–23.

Murdock, Robert M. "Agnes Martin: New Paintings." *Review* (April 15, 1998): 27–28.

Naves, Mario. "Agnes Martin's 10 Striped Canvases: Nuanced or Just Not Boring?" *The New York Observer*, May 22, 2000, 14.

"New Agnes Martin Gallery." *ARTnews* (October 1997): 55.

"New Agnes Martin Gallery to Highlight Reopening of Harwood Museum." *Tempo* (September 11, 1997).

Newhall, Edith. "Talent Purely Martin." *New York Magazine* (February 20, 1995): 90.

Prose, Francine. "The Sound of Silence." *ARTnews* (December 1999): 142.

Sandler, Irving. "Agnes Martin Interview." *Art Monthly* (September 1993): 3–11.

Schwabsky, Barry. "Agnes Martin." *Artforum International* (April 1997): 90.

Shaw, Leslie Ava. "Agnes Martin: PaceWildenstein Gallery." *The New York Art World* (June/July/August 2000): 17.

Simon, Joan. "Perfection Is in the Mind: An Interview with Agnes Martin." *Art in America* (May 1996): 82–89, 124.

Smith, Brydon. "The Innocence of Trees." *Canadian Art* (Fall 1996): 109.

Sutherland, Giles. "Around the Galleries: Agnes Martin and John McLaughlin." *Times* (Edinburgh), September 8, 1999, 37.

Tarlow, Lois. "Profile." *Art New England* (April/May 1994): 25–27.

Tennant, Donna. "In Search of Perfection: The Art and Life of Agnes Martin." *Museum and Arts Magazine* (September 1993): 28–31.

Weinstein, Joel. "Richard Tuttle and Agnes Martin: Modern Art Museum of Fort Worth." *Art Papers* (November/December 1998): 61.

Wilson, MaLin. "Agnes Martin." *THE* Magazine (December 1993): 47.

Editor: Polly Koch
Design: Don Quaintance, Public Address Design
Design and production assistant: Elizabeth Frizzell
Typography: Composed in Avenir (display) and Fairfield (text)
Color separations : C+S Repro, Filderstadt-Plattenhardt, Germany
Printing: Cantz Druckerei, Ostfildern-Ruit, Germany

This page is handwritten scratch arithmetic and cannot be reliably transcribed.